Inspired Ink

Amy Church

Amy Church

INSPIRED INK

ISBN: 978-0-578-40980-1

Cover art by Amy Church

Edited by Kelsey Klug

Book and cover design by Gilsvik Communications

First Printing 2018

10 9 8 7 6 5 4 3 2

Contact for more information:

Amy Church
artandverse1@gmail.com
218-830-1281

This book is dedicated to my parents, Jerry and Joanne Church. Their love for our family and their encouragement to explore the world, in person or through a book, were gifts that last a lifetime.

Contents

About this book

I fill my time with words. I read books, enjoy writing, do crossword puzzles, edit publications, play word games, am a spelling expert, think about word origins, look for the common root of unknown words, love hearing and using a play on words. Words grab me, interest me, and guide me. This book was a chance to put my thoughts and creative use of words into your hands. Many of my verses are very personal, written with a specific person or event in mind, yet still holding some universality for every reader, I hope. In others, I share a view to helping all of us find our way in this world, recognizing that it will be different for each of us. And I got to combine my words with my art! Color and design, and their movement and energy, make me happy – both in the creation of the artwork and the joy it brings me when complete. Just as words speak to me, so does the art, and together, I offer them as my gift to you.

Inspiration

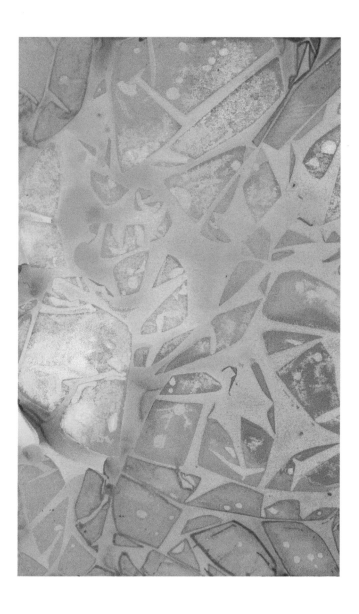

Find your core

The essence that gives wholeness

The energy that gives sustenance

The strength that gives guidance

The uniqueness that is you

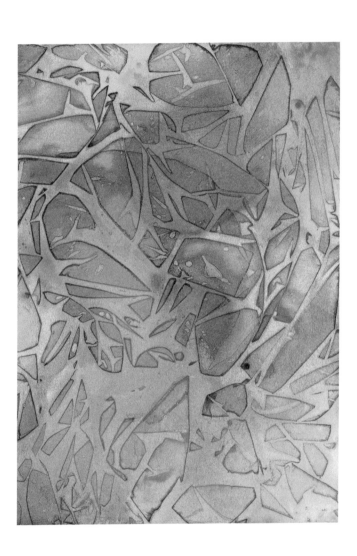

Inspired Ink

Do you know where you're going?
Do you know how to get there?
Or do you embrace the open doors
Peer around the next corner
Delight in the path that reveals itself

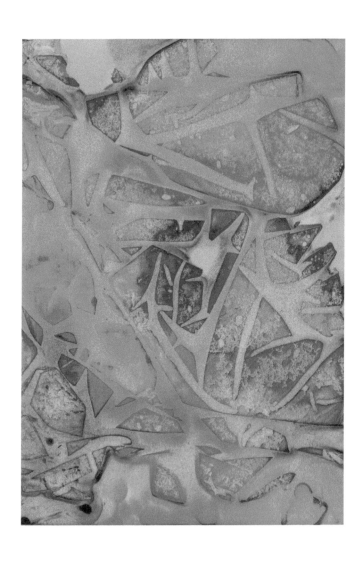

Life is a dance

Sometimes alone, sometimes not

With music to soothe

With music to move

With music to drive your feet

To the drumming of your heart

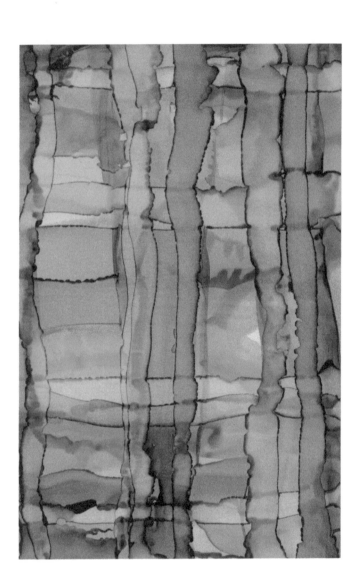

The unexpected,
random occurrences and life surprises
Can give us the freedom to grow

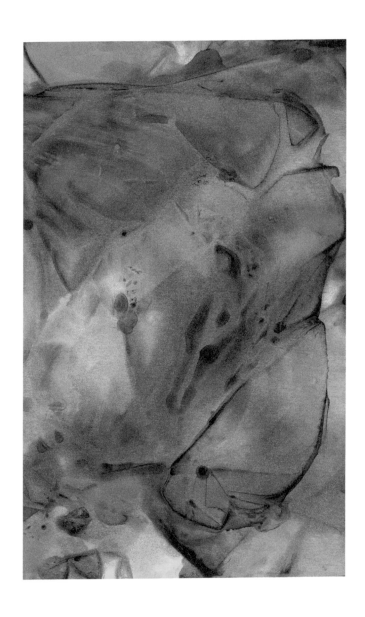

Inspired Ink

At various points in our lives
We find ourselves facing different directions
And difficult decisions
Look for the sources of inspiration and guidance
To help us find our way

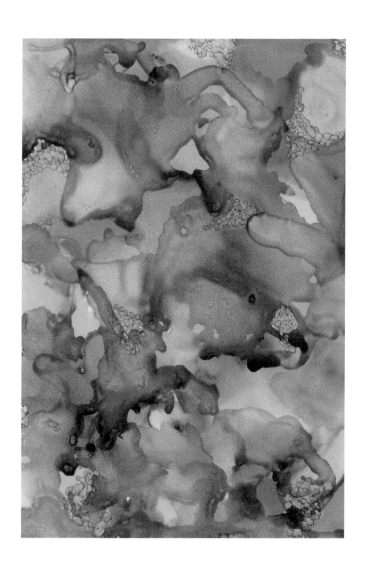

Inspired Ink

Life-sustaining waters run deep
Moving, cleansing, swirling, and changing
Forming new paths with their waves
Leading you along a river of truth

Movement finds a way

Movement of the mind, the body, the spirit

All will lift you and sustain you

Moving you to better days

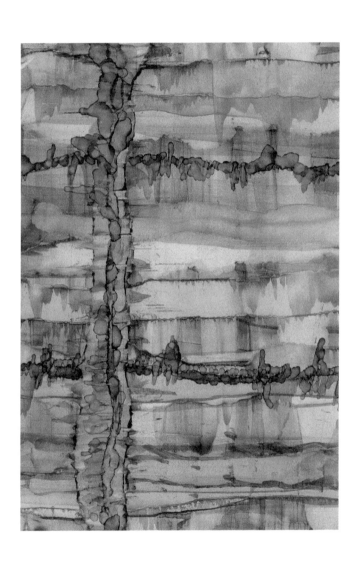

Inspired Ink

Life's tapestry builds upon itself
What comes first weaves into our future life,
and in turn, is forever connected to our past

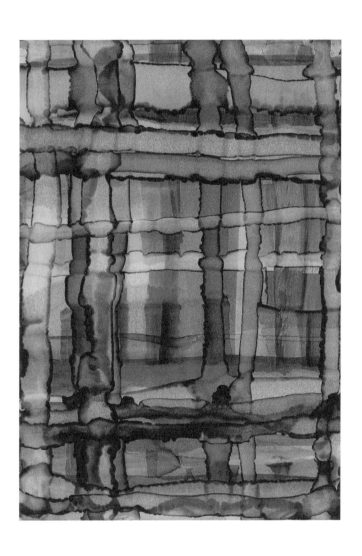

Inspired Ink

Layer by layer, our lives are woven
Adding color and texture each step of the way
That journey's loose ends
Are still to be lived and connected

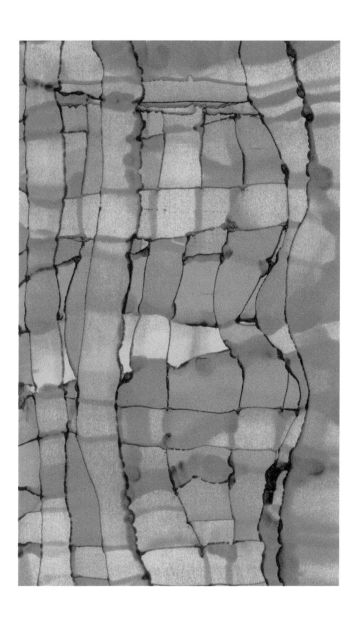

Everyone's journey is different
I don't know where they started
Nor where they hope to go
I can only wish them success
As I reach for my own stars

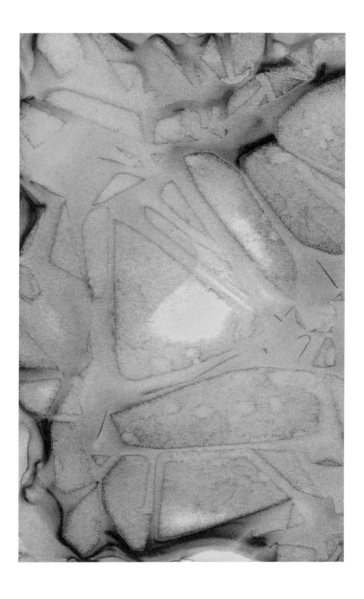

There are days when solitude feels right

Taking time for reflection and introspection

There will always be days full of chaos

So take today just for you

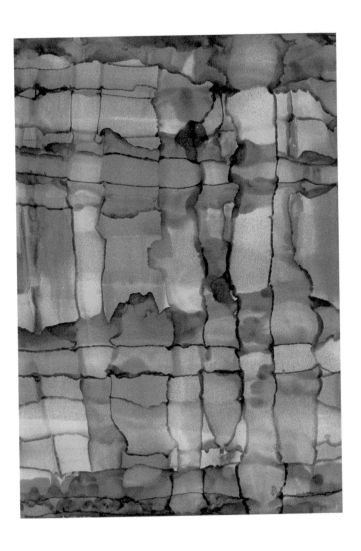

Find your strength, your guide, your direction
Hold fast to it, letting it draw you forward
Dismiss the scatter around you
Knowing you are on your way

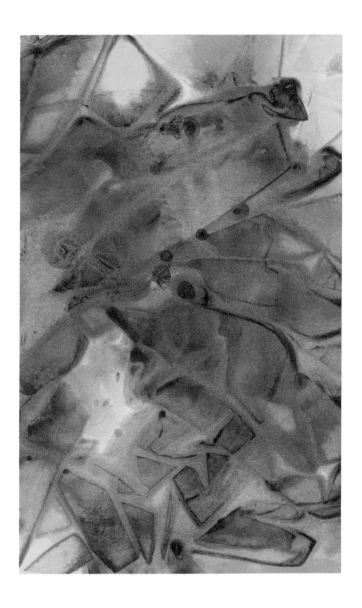

The world is not for us nor is it against us

We are the world and the world is us

We create that which affects us

Our actions are our lifetime companions

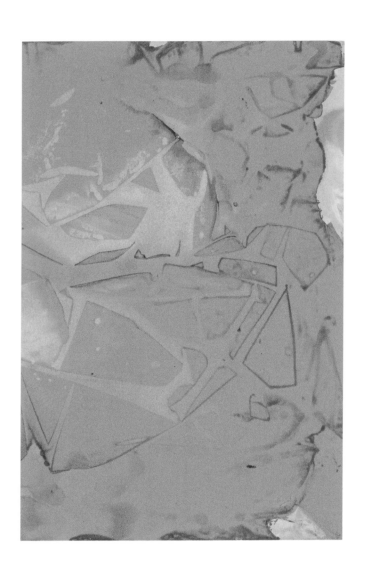

We can seek connection and reject exclusion
We can seek relationship and deny isolation
We can seek communication and open up silence
We can be a part of the positive and change the world

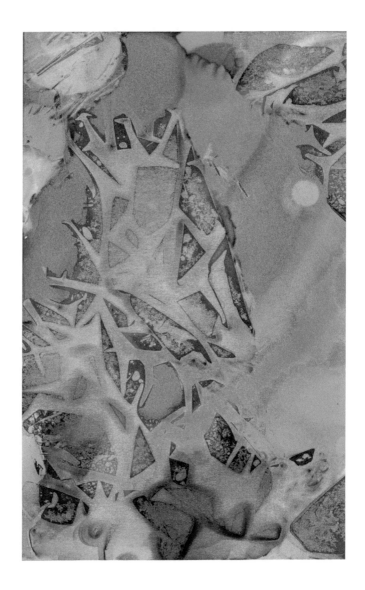

Speak your truth and share it
Own your place and know it
Find your path and walk it
Love your life and give thanks

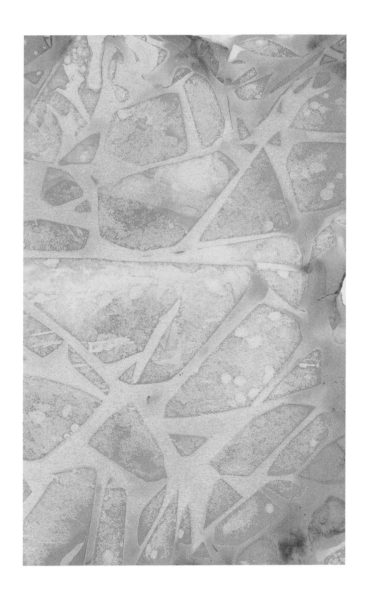

Inspired Ink

Rewrite the rules

Forge a new path

Find your own truth

As you chase life's carrot

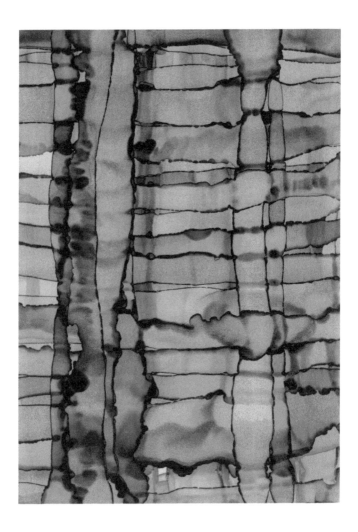

Inspired Ink

Life offers many paths giving one new beginnings
while building on what's come before
Full of strength and nuance,
yet fresh and everchanging
It can circle back on one's own history
and sometimes forge new trails to explore

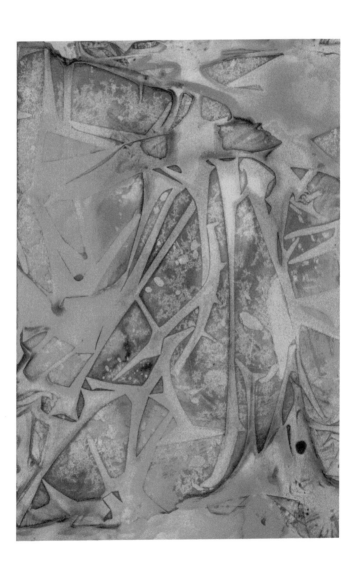

Life is full of seeking answers
Sometimes we find answers in the sky,
At times in a child's eyes, and often in our hearts
Be open to the answer finding you

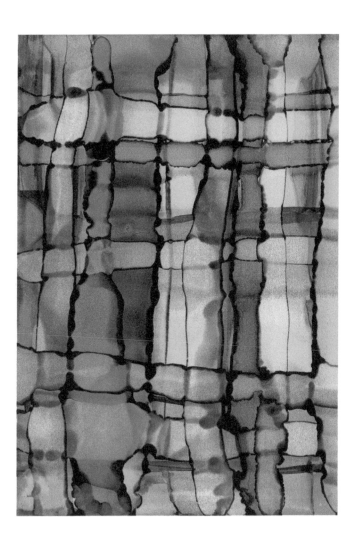

Inspired Ink

Is there a road to follow
Is there a map already drawn
Or do you trust your own feet
Your own heart, your inner guide
To find your way in life
Forging your own path forward

Family

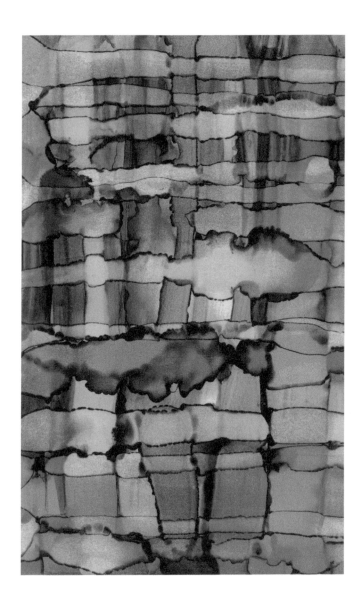

Inspired Ink

To be among family is like a quilt
Some constants give comfort
Other constants add layers
To know, to expect, to cherish
Our laughter and our tears
Our music and our colors
A treasure pieced together

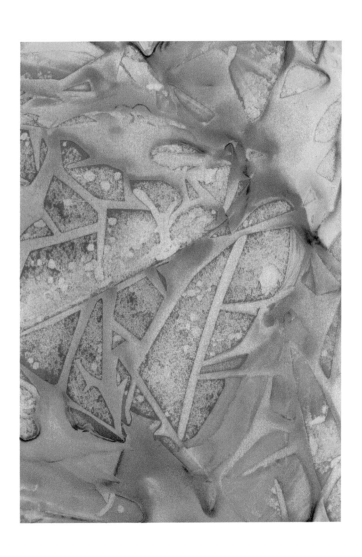

Inspired Ink

A mother's love envelops

Guiding hands, warm hugs, sweet kisses

Letting loose the curious, holding close the fearful

Ever present with love abiding

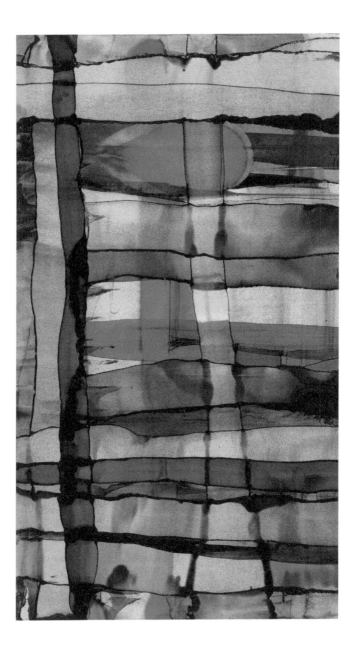

Inspired Ink

My dad unveiled the stars for me

My dad taught me how to swim

He lived the golden rule

Showing me the ways of fairness and love

And is woven into my life

Surrounding me everyday

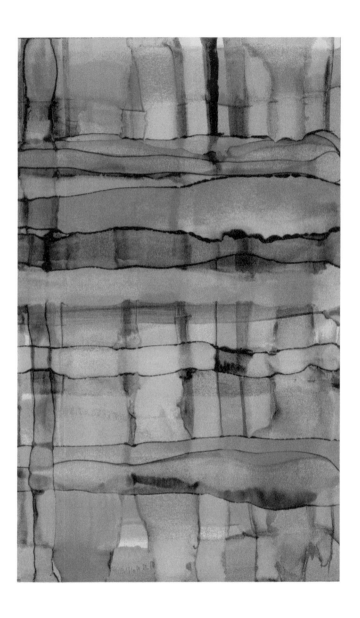

No one knows you like your sister
She knows what makes you laugh and cry
With her, you share all that life hands you
Sister in love and sister in spirit

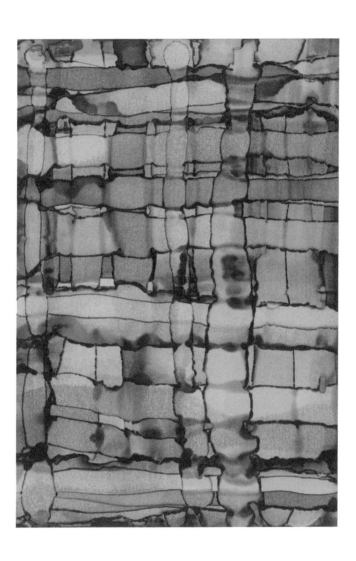

A brother is a part of you

And you of him

There is history, happiness, tears

There is fun and there is fight

The ties will run deep

Whether young or wrinkled with age

A gift throughout your life

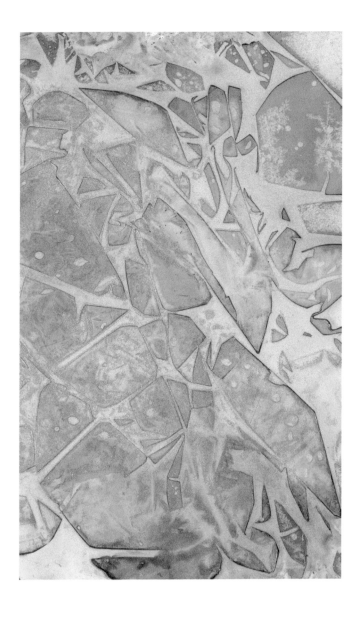

Filled with passion and joy

We found each other

We found love

A lifetime later, we are a family

Filled with comfort, closeness, gratitude

And always joy

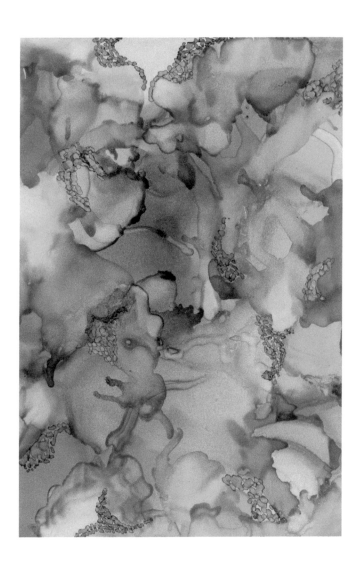

Inspired Ink

The enormity of the universe teaches us
To focus on our actions in the here and now
To pay attention to our loved ones who surround us
It is our world within the greater space
That we can touch

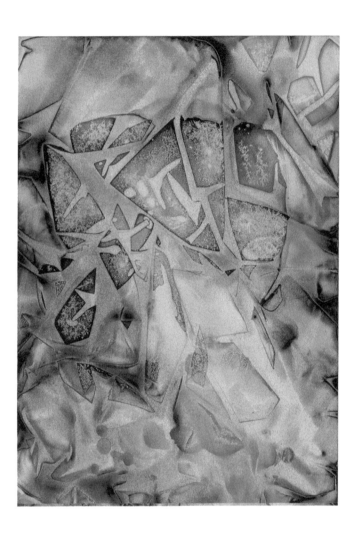

Celebrate it all

The years, the commitment, the better, the worse

Embrace it all

Knowing these years are the journey of a lifetime

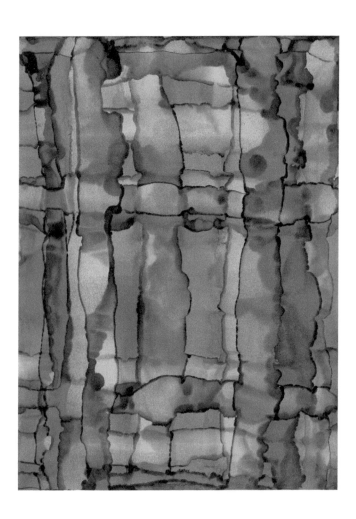

Inspired Ink

You taught me daily
You loved me even more
You shared all that you had
Helping me grow
Guiding me on how to be me

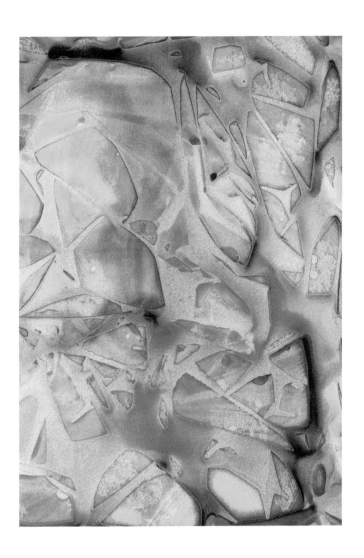

Silliness, seriousness, sameness

Sisters experience it all

Living along different paths yet on a shared journey

Always knowing they are with you

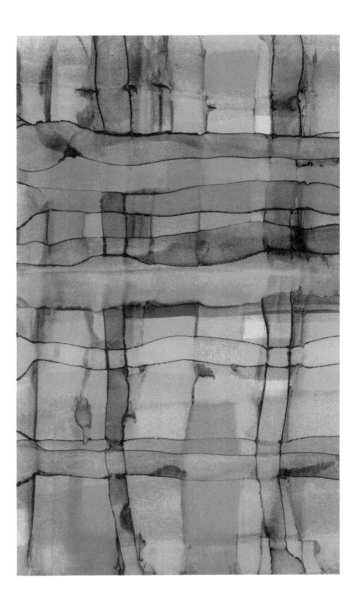

Inspired Ink

A girl has such spirit and stamina
Full of curiosity and intelligence and grace
Finding her way in life
Despite obstacles and stereotypes
To become the person she chooses to be
A gift to herself and those who love her

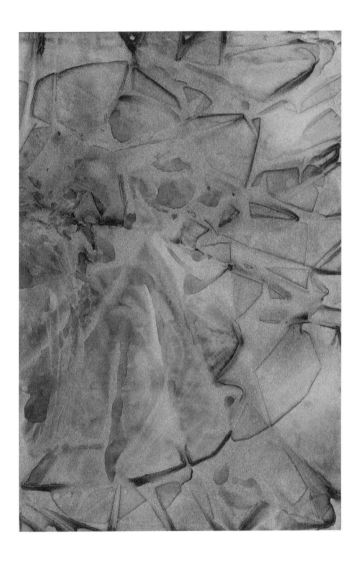

Inspired Ink

The safe and the familiar are a blessing
Risk and the unfamiliar are a blessing
To each other, each of us is a blessing
Relish that truth

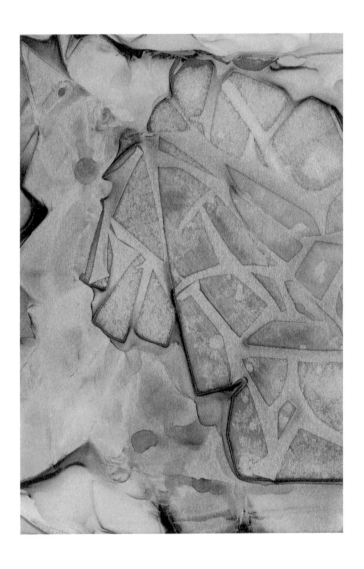

Inspired Ink

Boys are in constant motion

Boisterous and bruised

Bikes, balls, and bugs

Endless energy running full speed ahead

So hold on and enjoy the ride

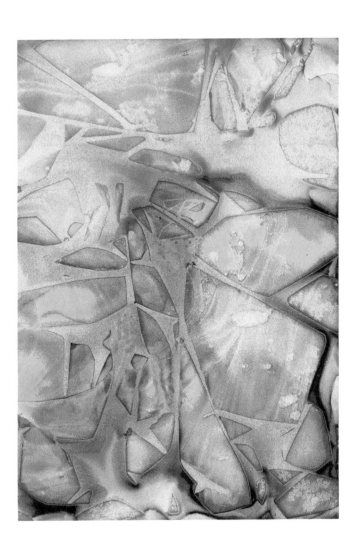

A mom would give anything
A mother would give up everything
To wrap her child in love
To nurture her child's flight

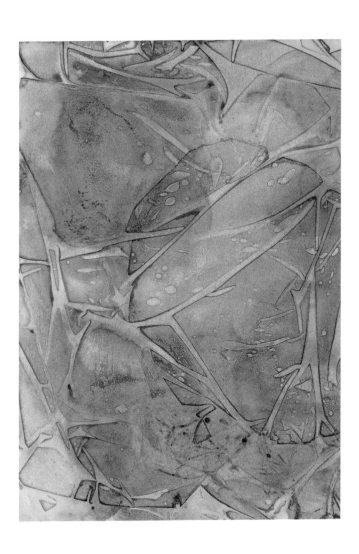

Deep appreciation of nature
Curiosity and a desire to learn
Respect for all people and peoples
Ability to discuss, evaluate, and reason
The joy of watching you be a grandpa
Gifts from my father

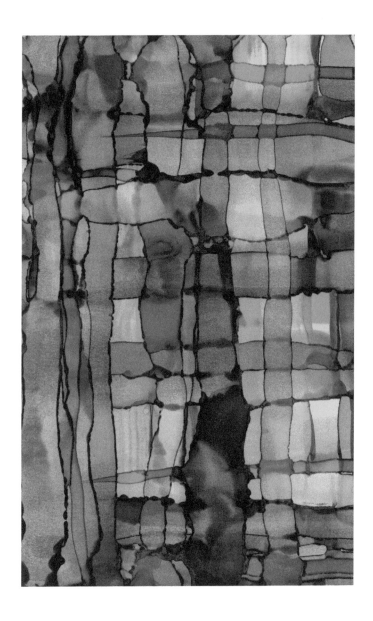

Love isn't always fun and fireworks

Nor passion and perfect touch

We can start down separate paths

By a word, a look, a hurt

Yet love can bring those paths back together

Reforming the connection that is us

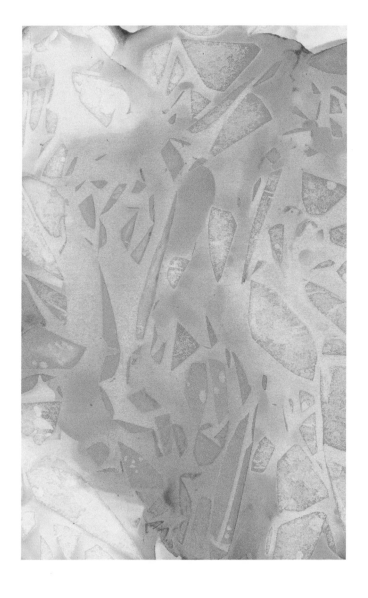

Inspired Ink

Growing up with brothers is a wonderful thing

Shared exploring and experiences

Playing hard, bumps and bruises

Always on the go

Yet surrounded by strength, love, and protection

Knowing you're never alone

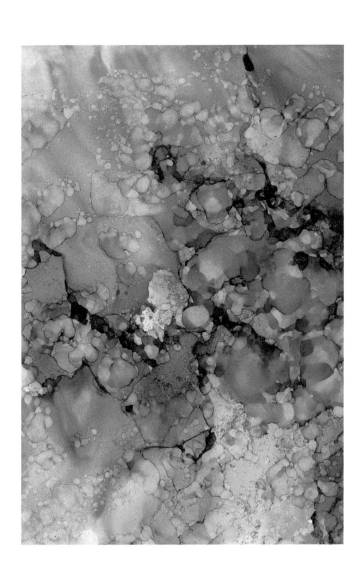

Sisters, by birth or by choice

The gift is the same

She's just a reach away

Knowing you and loving you

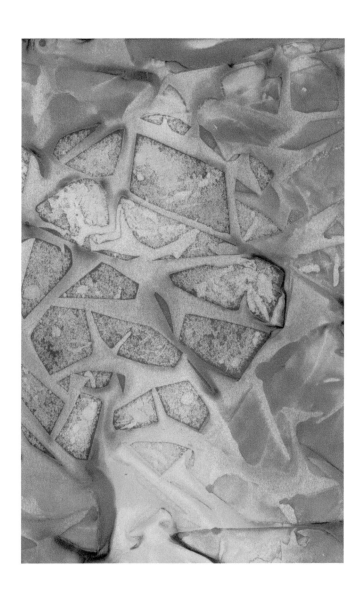

Friendship means that you are not alone

A gift as you travel life's path

Not always seen but ever present

Ready to share, ready to catch, ready to love

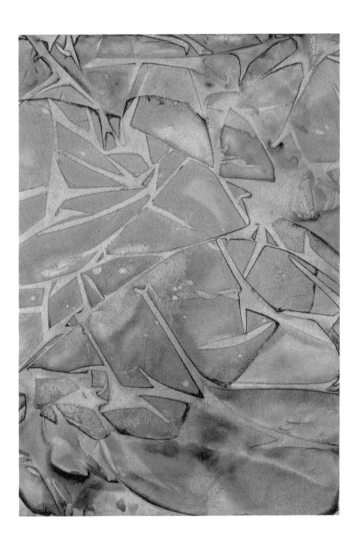

Inspired Ink

She started out with energy and curls and curiosity
She continued with reading and art and learning
She laughs, she questions, she helps, she loves
She is generous, creative, and smart
An endless blessing is my daughter

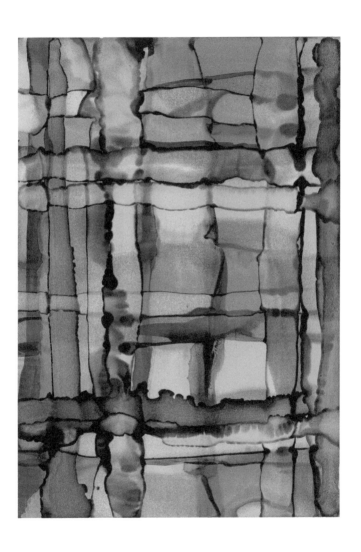

Inspired Ink

When I am joyful, I look for you
In my sorrow, I seek your face
Living day to day, I share life with you
Together, finding our way

Inspired Ink

Upon the leaving, the truth will out
The clarity of water and sky
The strength of wind and tree
My yearning for love
My fear of loss
Yet filled with the blessings
Of the bloodlines that run deep

Loss

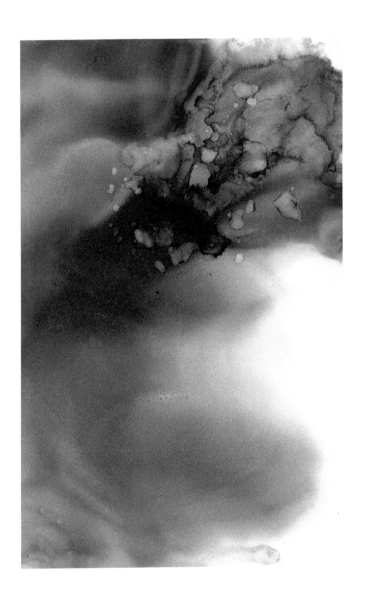

When you lose someone, there is no light
Darkness and weight with no end
Yet a way will find you through your grief
To hold you and lead you forward

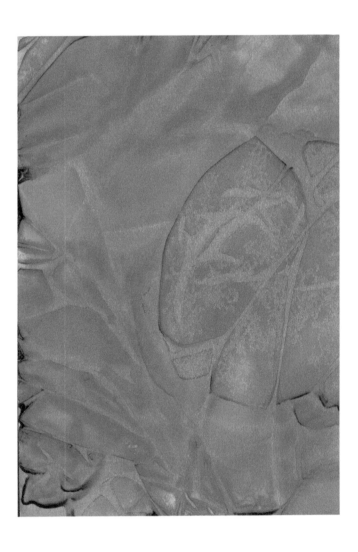

Inspired Ink

Without them, we would be lost
The spirits of those that led the way
The breath of each living day
The wind that carries us forward
Filling and ever sustaining us

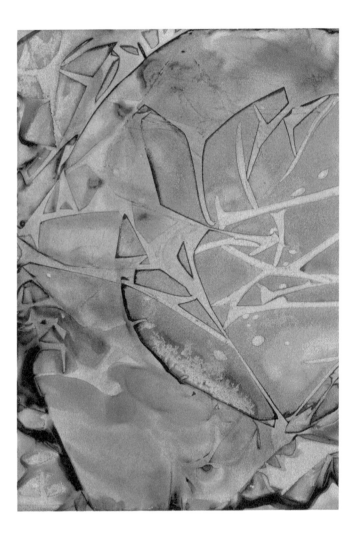

Inspired Ink

With whom do you share your joy?
To whom do you turn in sorrow?
Who will help you discover your truth?
Your parent, your friend, your love
Find them and hold fast

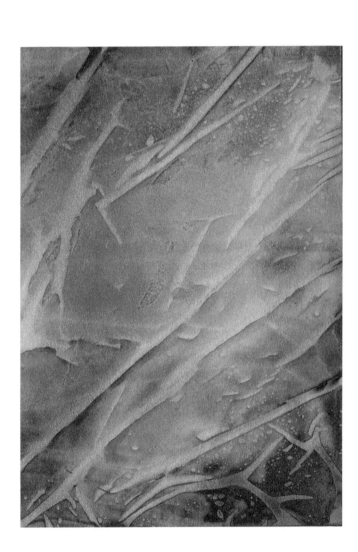

Inspired Ink

Knowing what was coming
Yet not believing it ever would
I've lost him before he's gone
Beside me but out of reach
How do I bear it?

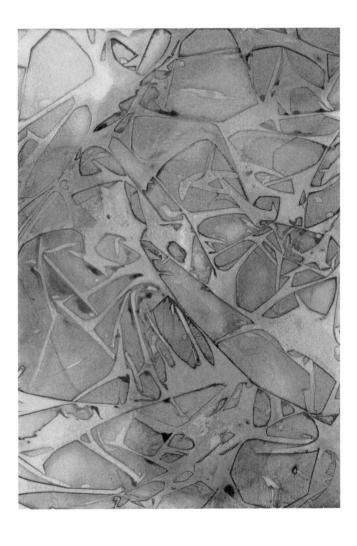

Inspired Ink

The wind carries you to me
Your spirit surrounds me
Blowing by and circling back
Your presence is known

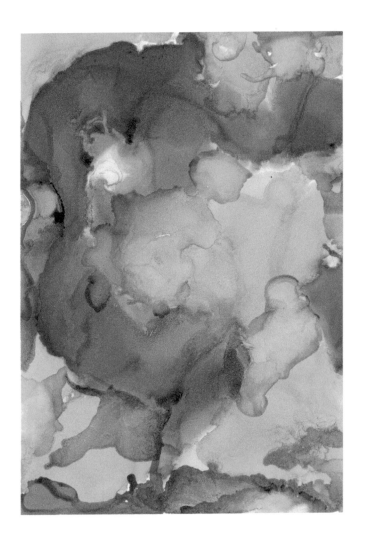

Inspired Ink

The loss hits again and again
Waking me from sleep
The nightmare's pit surrounds me
I know there must be a way up and out
But no ladder is found

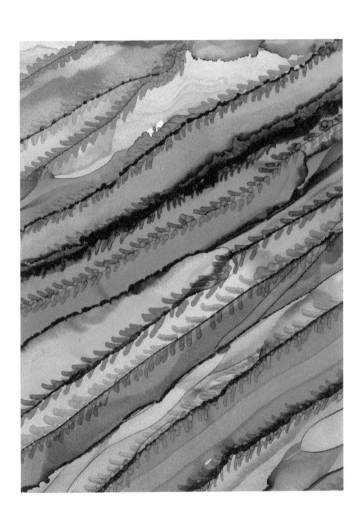

Inspired Ink

Like the desert

Amidst the harsh and desperate

Hope emerges

The berries of the juniper tree

The blossom of the saguaro

The nectar of the prickly pear

Showing and sharing life

Helping us move forward

Nature

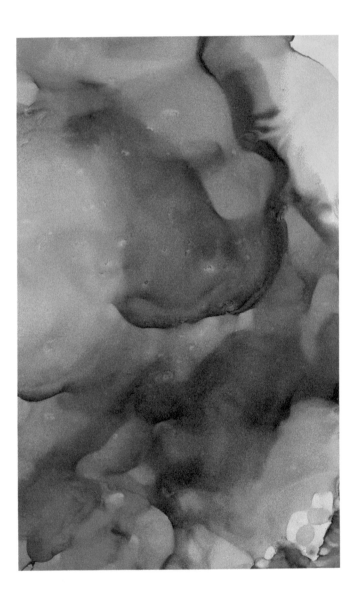

Inspired Ink

In the strength of the rock
In the crashing of the waves
In the whispering of the wind through the white pine
You are here

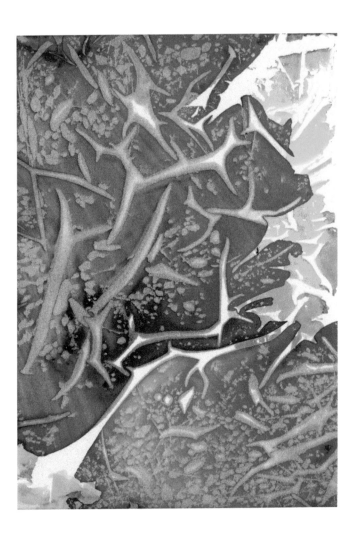

Inspired Ink

The wind startles me
A catch in my breath as it flows around me
Now moving through me
Filling the empty with life
Making hair fly and blood move
Pushing me to take that next step

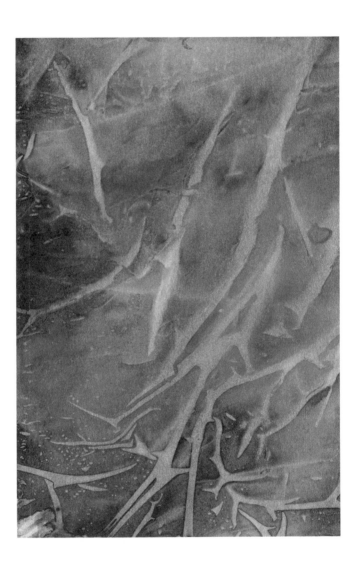

Inspired Ink

Will wonders never cease?
The promise of a sunrise
The fire of the sunset
The allure of the stars
The dance of the northern lights
May wonders never cease!

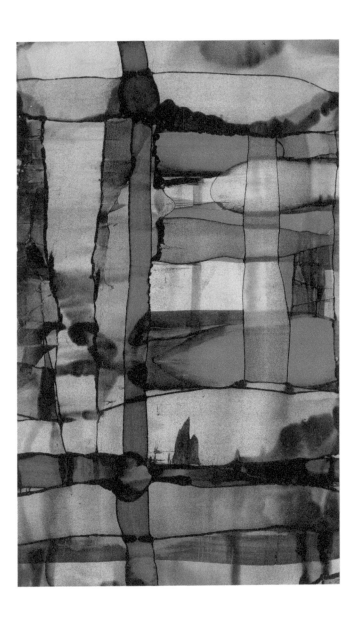

Inspired Ink

Water and woods, winged and wild ones
Nature's solitude will find you
Surrounded by a cacophony of life

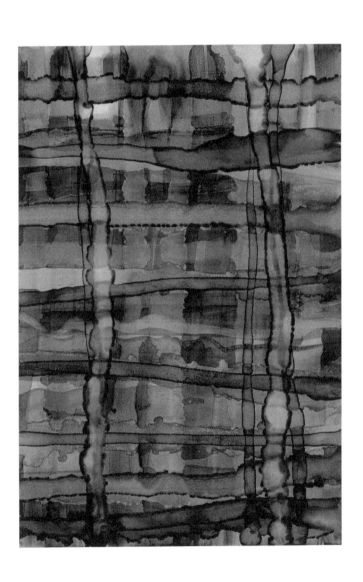

Inspired Ink

Keep it green and keep it living
Let the trees flourish and the waters run
Breathe the freshness and feel the rain
As we live, so shall the earth

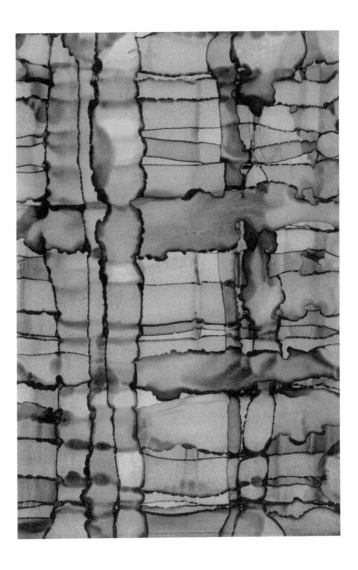

Inspired Ink

A sunset's color

An ocean's depth

The earth's texture

Blended building blocks

Providing strength and beauty to our days

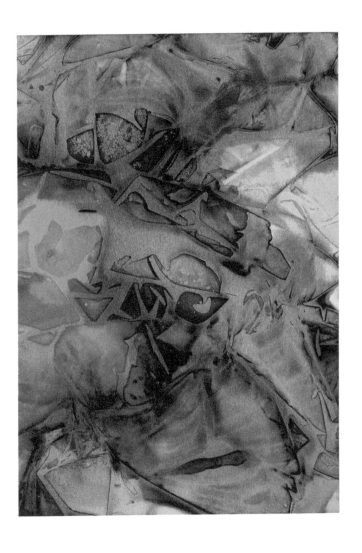

Inspired Ink

Spring's tentative promise awakens and peeks out
And summer bursts forth in luscious bloom
Fall brings its inevitable reckoning
As winter hunkers down for the long sleep

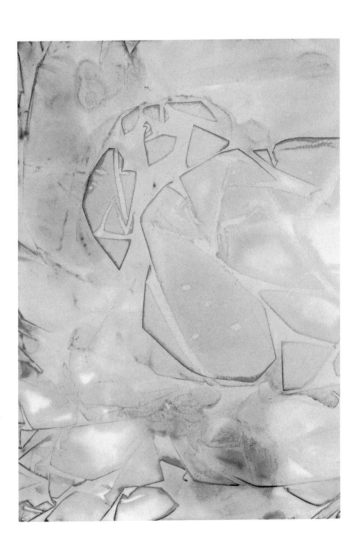

Sky surrounds from above

With height infinite

Yet with depth unimaginable

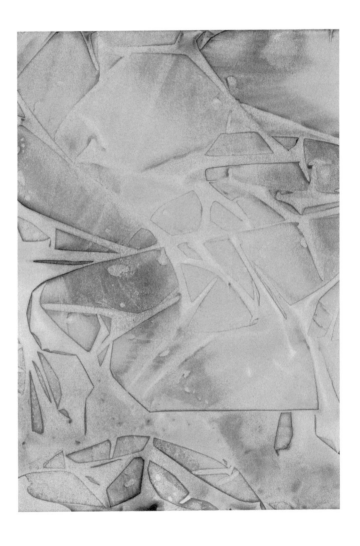

Sit by the lake

Pause for reflection

Hear the message in the lapping waves

Feel its cleansing spirit

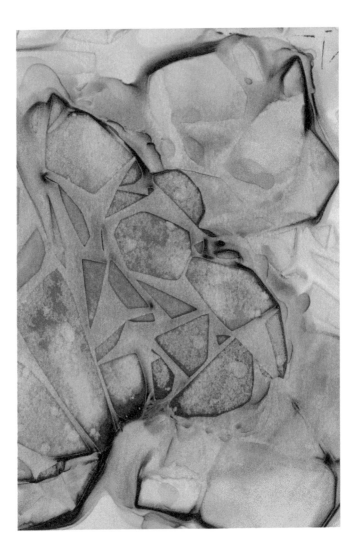

Nature makes us better
The waters give us life
The trees give us strength
Animals keep us company
Flowers give us beauty
And the sky gives us hope

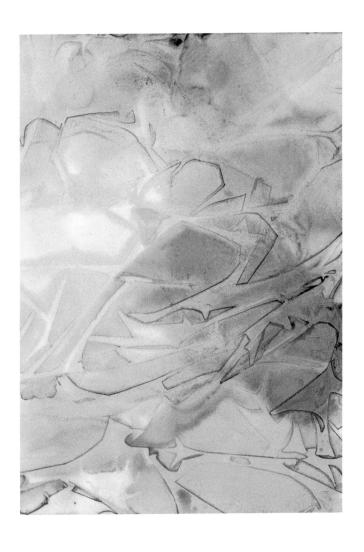

Inspired Ink

A craving for the wild seizes me and I must go
To the north, to the Lake
To clarity, to renewal

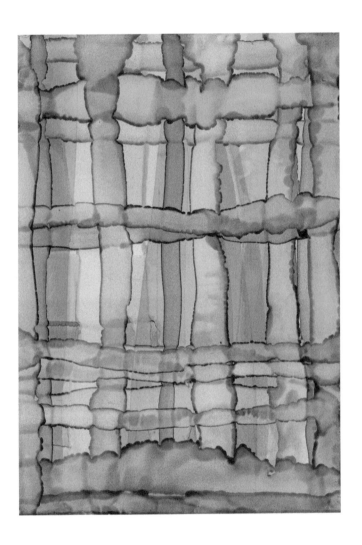

Inspired Ink

From where do we come?
From nature and from history
From water and from mothers
Following paths of newness and exploration

Joy

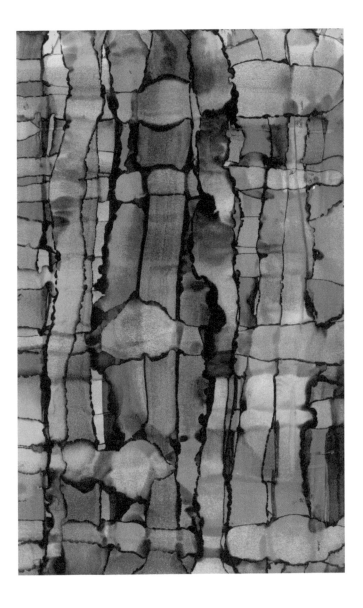

Inspired Ink

A collage of emotions
finds a different purpose for you each day,
drawing you into its depths
or lifting you up with its energy

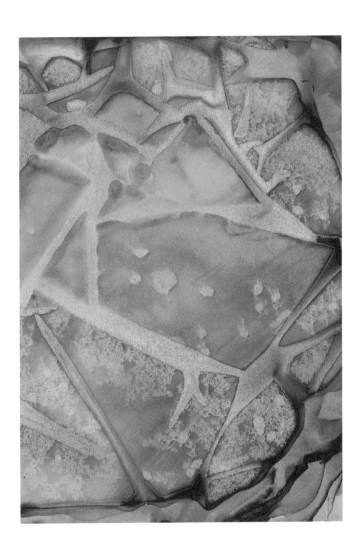

Inspired Ink

Everybody's happy looks different

Dancing, playing, and moving muscles

A day without pain

The first bite of an exquisite dish

Any bite at all

Surrounded by friends and laughter

Being alone and quiet

Everybody's happy looks different

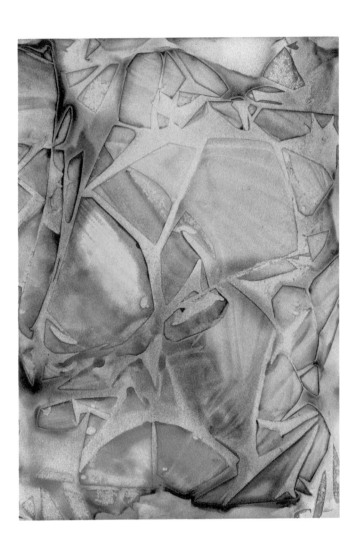

Inspired Ink

Make it a fun day
Take time for the frivolous
Laugh out loud and play in puddles

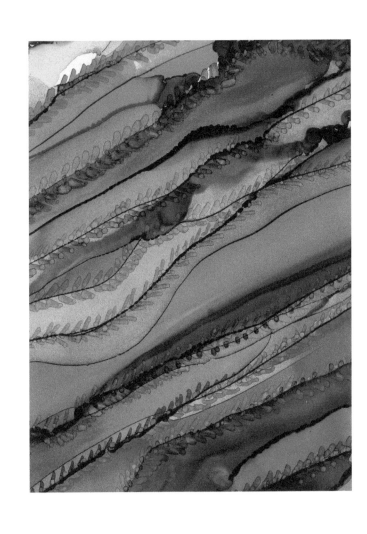

Inspired Ink

It is the little things that are a gift
Wading in the ocean surf
The face of a sleeping baby
The song that makes you move
A juicy fresh peach
The small and the special
Make the big picture grand